D0325621

THE BRUMBACK LIBRARY
OF VAN WERT COUNTY
VAN WERT, OHIO

GAYLORD

PEOPLE

IN WATERCOLOR

Art Director: Lynne Havighurst
Designer: PandaMonium Designs, Boston, MA
Cover Image: Pat Swan
 Hand in Hand
 22" x 30" (55.9cm x 76.2cm)
 Strathmore 400 Series
Introduction Image: Leslie Rhae Barber
 Listening with the Heart
 20.25" x 26" (50.8cm x 66cm)
 Arches 300 lb. cold press

First published in the United States of America by:
Rockport Publishers, Inc.
146 Granite Street
Rockport, Massachusetts 01966-1299
Telephone: (508) 546-9590
Fax: (508) 546-7141

Distributed to the book trade and art trade in the United States by:
North Light, an imprint of
F & W Publications
1507 Dana Avenue
Cincinnati, Ohio 45207
Telephone: (513) 531-2222

Other Distribution by:
Rockport Publishers
Rockport, Massachusetts 01966-1299

ISBN 1-56496-241-5

10 9 8 7 6 5 4 3 2 1

Printed and bound in Hong Kong

PEOPLE
IN WATERCOLOR

SELECTED BY

BETTY LOU SCHLEMM

ROCKPORT

ROCKPORT PUBLISHERS
ROCKPORT, MASSACHUSETTS
DISTRIBUTED BY
NORTH LIGHT BOOKS, CINCINNATI, OHIO

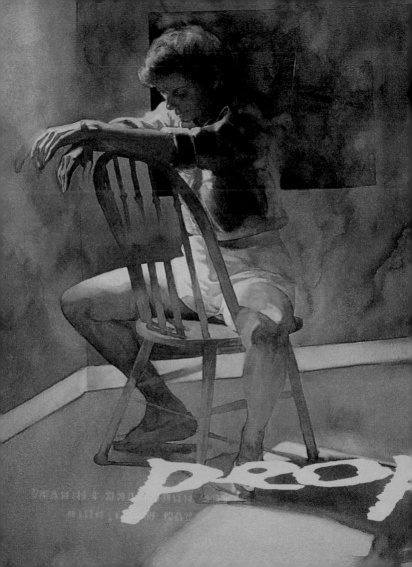

INTRODUCTION

Remembering, knowing, and ensuring the preservation of a person in the collective memory, is the impetus of portrait painting. It is a demanding, often thankless endeavor whose primary compensation is the satisfaction of a rare insight into the human condition, or particular lives. This in turn creates a community of acceptance, or the will to change.

Commissioned portrait painters usually know their subjects only from an idealistic public image which they are hired to perpetuate, yet compelled as artists to unveil. Meanwhile, many forces work against the painter's instinct to probe beneath the layers of appearance.

Portraits of people we think we know or love are perhaps the most challenging to our notions of what makes up an individual. What a person does for a living, the communities they belong to, the things they own or wear, the relationships they form, their gestures—all vie for possession of the essential, yet fluid identity we call by name. It is a dialogue of surface and substance. Whether fixed in time or place, or an ephemeral impression, a portrait must be, ultimately, both of and beyond the person depicted and the painter's commentary.

Good portrait painting is of such unquestionable veracity that you will never see the person, or yourself, the same way again. We must recognize the person, acknowledge the artist's lens and decide if this tempest is in a teapot or truly a wind with fire.

Erica Adams
Painting Faculty
Tufts University
School of the Museum
of Fine Arts, Boston

∇ **Irwin Greenberg**
Victoriana
11" x 14" (27.9cm x 35.6cm)
5-Ply plate finish bristol board

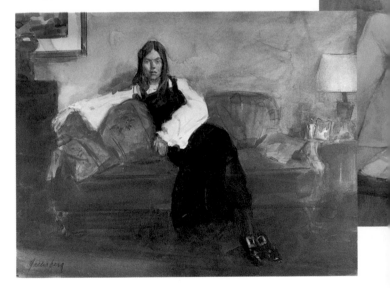

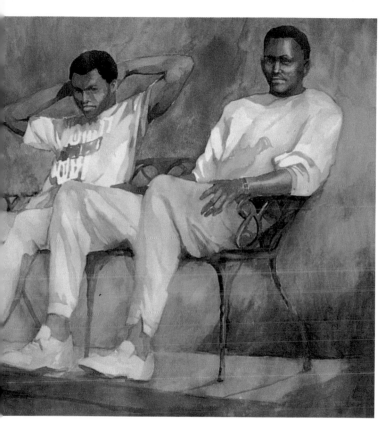

A **Barbara George Cain**
Bench Warmers
27" x 30" (68.6cm x 76.2cm)
Arches 140 lb. cold press
Mixed media. Gesso

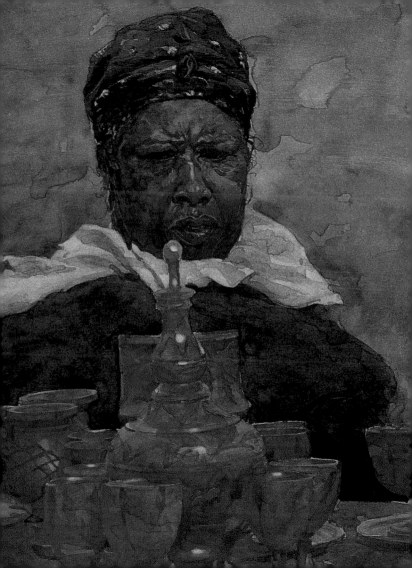

◁ **Bill James,**
A.W.S., P.S.A.
Flea Market
27" x 21" (68.6cm x 53.3cm)
Crescent #100 board
Mixed media: Gouache

▽ **Charlet F. Hager,**
N.W.S.
Homeless Vet
24" x 18" (61.0cm x 45.7cm)
Arches 140 lb. cold press

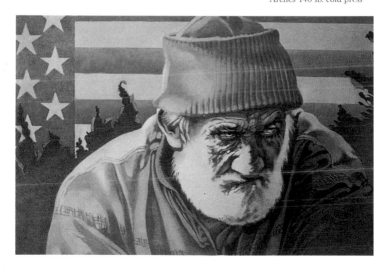

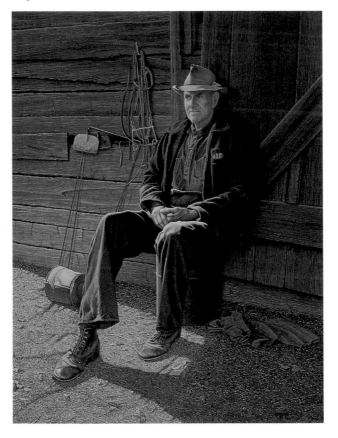

∇ **Joseph Manning**
The Kentuckian
18" x 24" (45.7cm x 61.0cm)
Mixed media: Egg tempera,
gesso on board

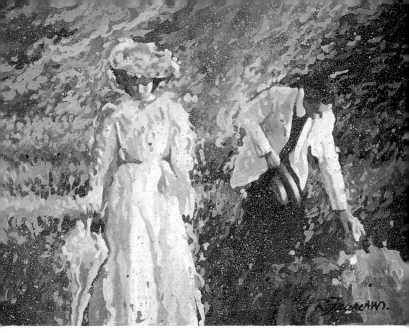

⋀ **Renée Faure**
The Suitor Series #3
10" x 14" (25.4cm x 35.6cm)
Arches 140 lb.
Mixed media: Gouache, metallic, opaque

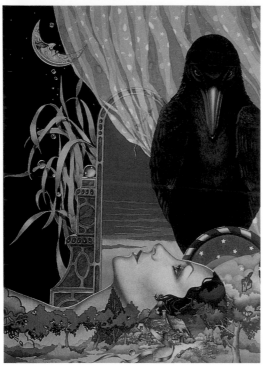

△ **Sabine M. Barnard,**
N.W.S.
At Night When the Ravens Are Blacker
22" x 30" (55.9cm x 76.2cm)
Arches 300 lb. cold press
Mixed media: Gouache

▷ **Joanna Mersereau**
Girl with Shawl
12" x 9" (30.5cm x 22.9cm)
Indian Village 300 lb. watercolor paper

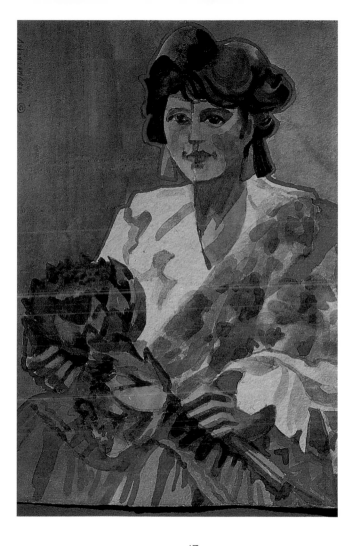

13
||||

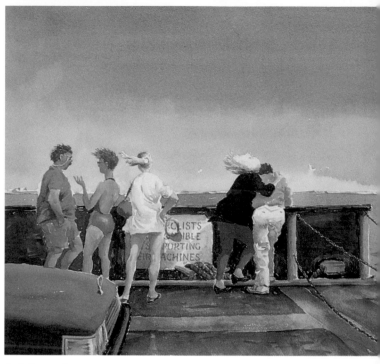

△ **J. Everett Draper,**
A.W.S.
Mayport Ferry II
14" x 21" (35.6cm x 53.3cm)
Arches 140 lb. rough

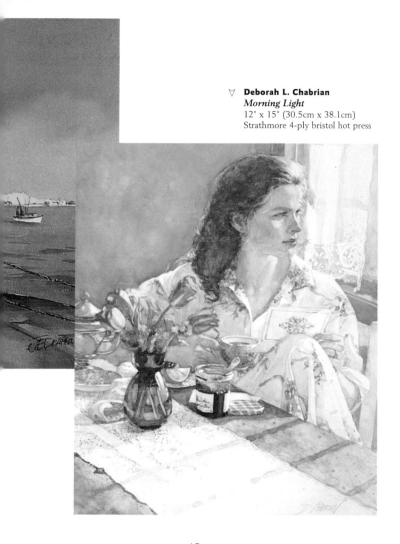

Deborah L. Chabrian
Morning Light
12" x 15" (30.5cm x 38.1cm)
Strathmore 4-ply bristol hot press

▷ **Donald A. Mosher**
The Tea Room
18" x 28" (45.7cm x 71.1cm)
300 lb.

▽ **Robert G. Sakson,**
A.W.S., D.F.
Rancocas
22" x 30" (55.9cm x 76.2cm)
Arches 140 lb. rough

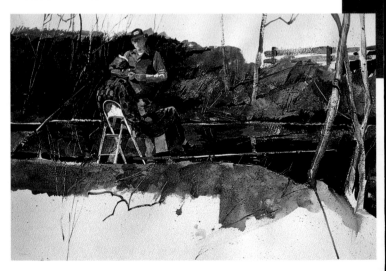

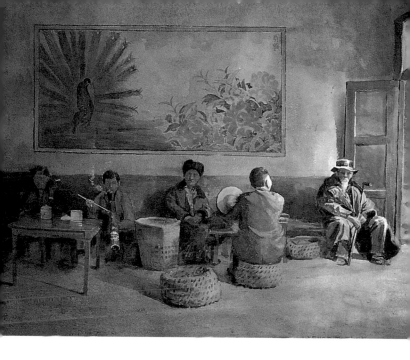

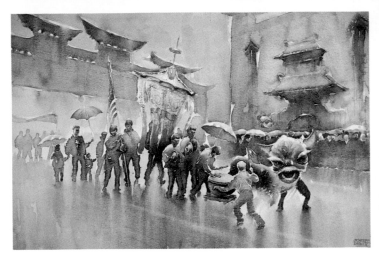

△ **Joseph Devito**
Chinatown Parade
19" x 28" (48.3cm x 71.1cm)
Fabriano Artistico 300 lb. cold press

▷ **Morris Meyer**
Tortola Carver
20" x 26" (50.8cm x 66.0cm)
Arches 300 lb.

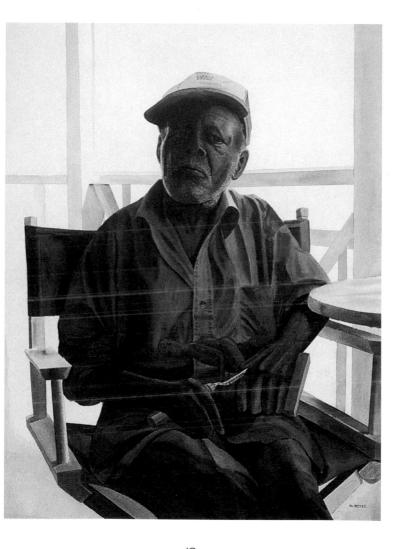

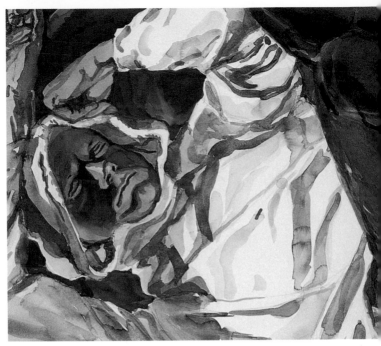

△ **Kay Ornberg,**
M.W.S., N.W.S.
Gale (red pillow)
22" x 30" (55.9cm x 76.2cm)
Arches 190 lb.

▽ **Arne Westerman,**
A.W.S., N.W.S.
Solitude
21" x 29" (53.3cm x 73.7cm)
Lana Aquarelle 140 lb hot press

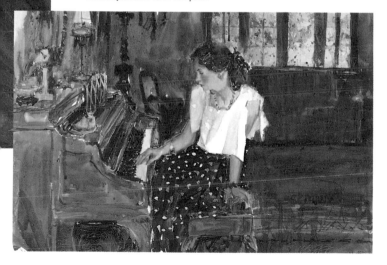

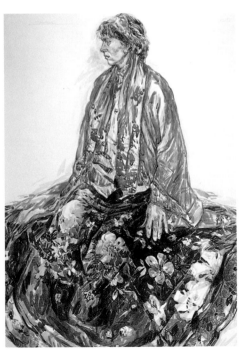

◁ **Donna Rae Hirt**
Dorothea
22" x 30" (55.9cm x 76.2cm)
Fabriano Artistico hot press

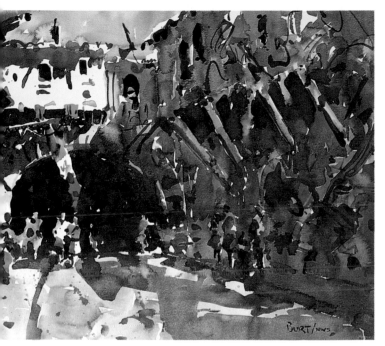

△ **Dan Burt,**
A.W.S., N.W.S.
Callejon III
22" x 30" (55.9cm x 76.2cm)
Arches 140 lb. cold press

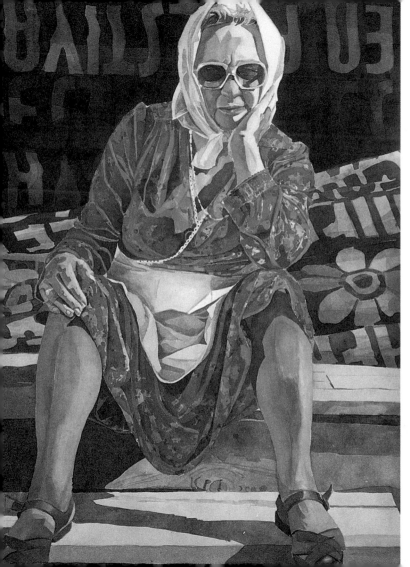

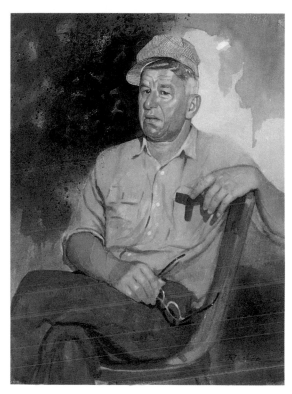

△ **Donald G. Renner**
Oliver, 60185
22" x 29" (55.9cm x 73.7cm)
Arches 300 lb. cold press

◁ **Bonnie Price,**
A.W.S.
By Myself
22" x 30" (55.9cm x 76.2cm)
Arches 140 lb. hot press

▽ Clarice Roberts
Meph
30" x 22" (76.2cm x 55.9cm)
Arches 300 lb. cold press

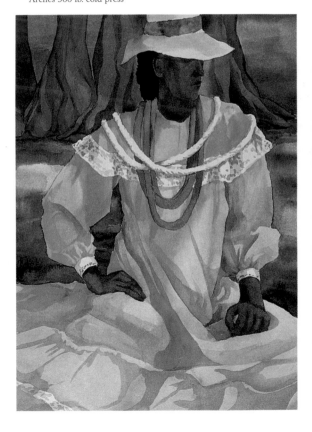

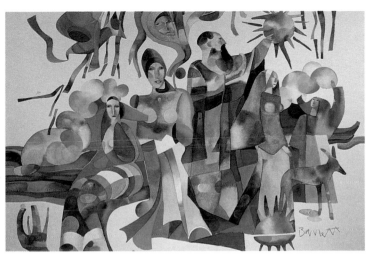

△ **Jack Barrett**
Tropical Magic
21" x 29" (53.3cm x 73.7cm)
140 lb. Medium surface

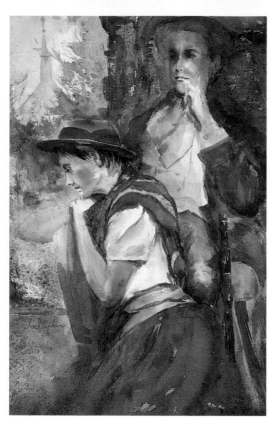

△ **Fealing Lin**
Resting
21" x 15" (53.3cm x 38.1cm)
140 lb. Cold press

▷ **Judy Morris,**
N.W.S.
She's Back
20" x 24" (50.8cm x 61cm)
Arches 300 lb. cold press
Mixed media: Transparent
watercolor, gouache

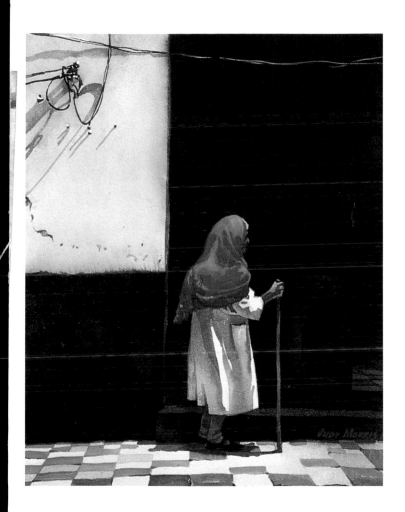

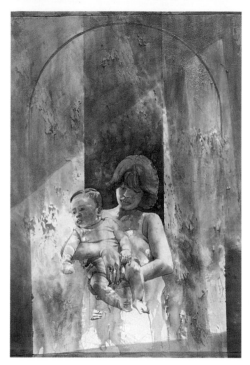

△ **Luis Llar Na**
Mother and Child
22" x 30" (55.9cm x 76.2cm)
Lana Aquarelle

▷ **Leslie Rhae Barber**
Listening with the Heart
20.25" x 26" (51.4cm x 66.0cm)
Arches 300 lb. cold press

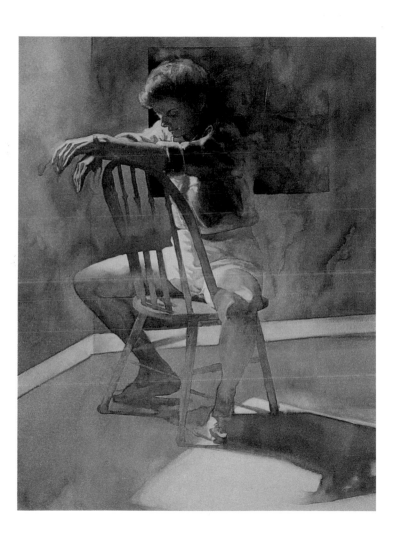

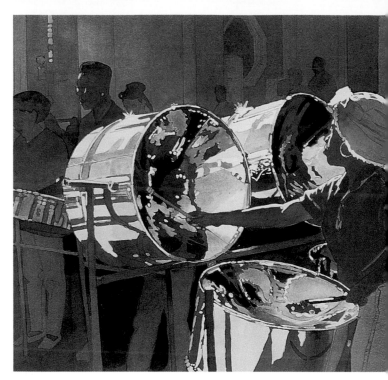

△ **Jean H. Grastorf,**
A.W.S., N.W.S.
Steel Drums
20" x 28" (50.8cm x 71.1cm)
Waterford 300 lb. rough

▽ **Joseph E. Grey II**
The Repose
22" x 30" (55.9cm x 76.2cm)
Arches 140 lb. cold press

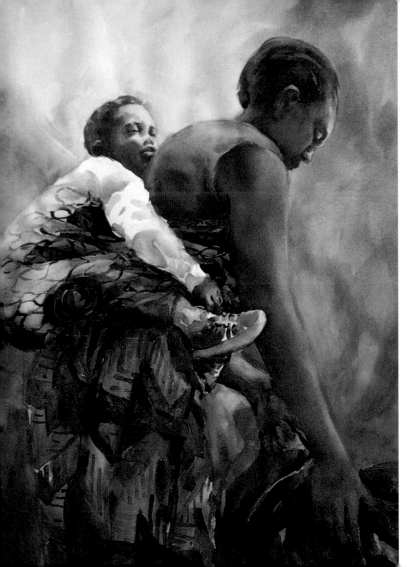

Betty Lou Schlem,
A.W.S., D.F.
Mother and Child
22" x 30" (55.9cm x 76.2cm)
Arches 140 lb.

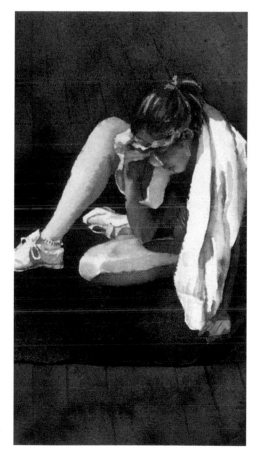

▷ **Sabina Harte Turner**
After the Workout
5.5" x 9.25" (13.97cm x 23.5cm)
Arches 300 lb. cold press

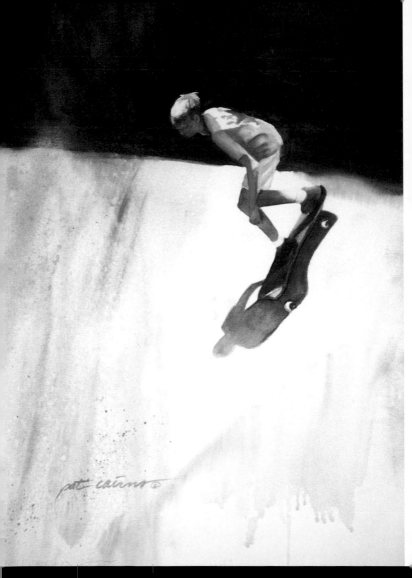

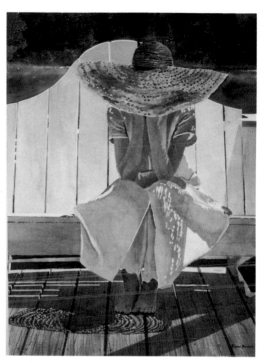

△ **Linda Baker**
Michelle Series: Contemplation
22" x 30" (55.9cm x 76.2cm)
Arches 300 lb.

◁ **Pat Cairns**
Skateboarder
22" x 30" (55.9cm x 76.2cm)
Arches 140 lb. hot press

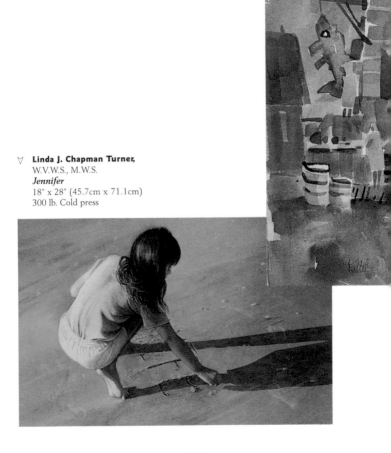

▽ **Linda J. Chapman Turner,**
W.V.W.S., M.W.S.
Jennifer
18" x 28" (45.7cm x 71.1cm)
300 lb. Cold press

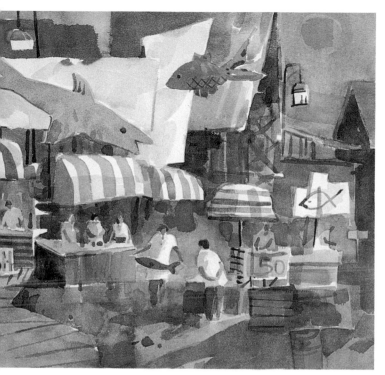

A **Anne Kittel**
Fish in Abundance
17.5" x 21.5" (44.5cm x 54.6cm)
Arches 140 lb. cold press

∀ **Jean R. Nelson**
It's Coming
22" x 30" (55.9cm x 76.2cm)
Waterford 140 lb. cold press

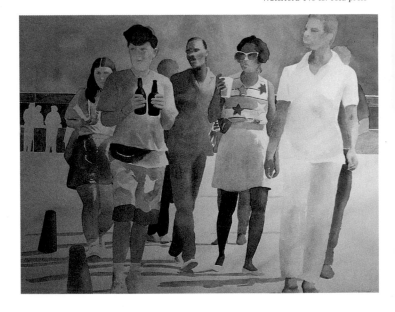

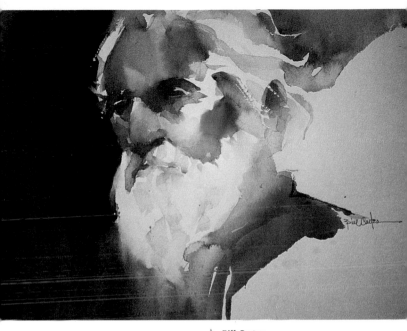

A **Bill Carter**
El Senor
15" x 22" (38.1cm x 55.9cm)
140 lb. Cold press 100% Rag watercolor
paper

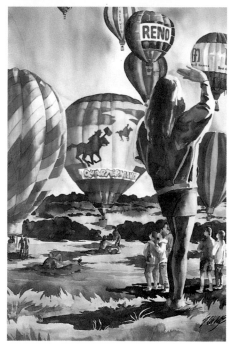

△ **Linda Savage**
Up, Up, and Away
28" x 36" (71.12cm x 91.4cm)
Arches 140 lb.

▷

Dee Wescott
Chit Chat
14.5" x 11" (36.8cm x 27.9cm)
Arches 140 lb. cold press

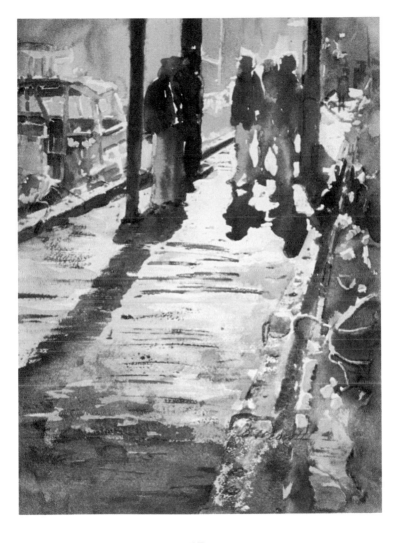

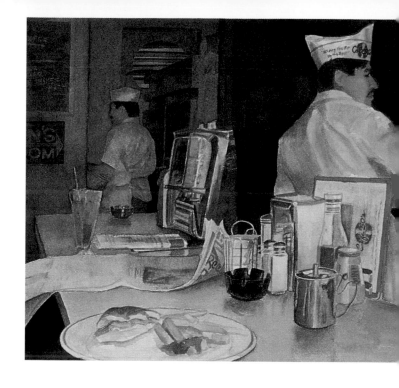

◁ **Mary T. Monge**
Behind the Color
30" x 17" (76.2cm x 43.2cm)
300 lb. Cold press watercolor paper

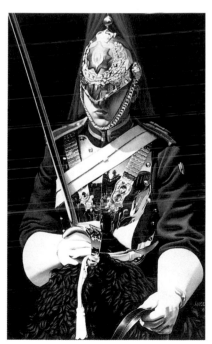

▷ **Peter Angelo**
The Guard
22" x 29" (55.9cm x 73.7cm)
Arches 140 lb. hot press

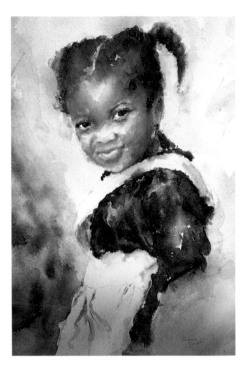

△ **Jeanne Ruchti**
After Church II
24" x 29" (61.0cm x 73.7cm)
300 lb. Rough

▽ **Charles Stratmann**
Crystal City Shirt Sleeve Band
30" x 40" (76.2cm x 101.6cm)
Strathmore 500 lb. heavy plate illustration board

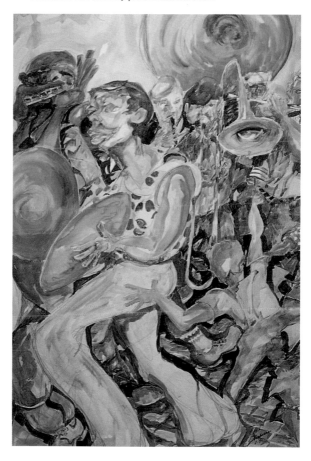

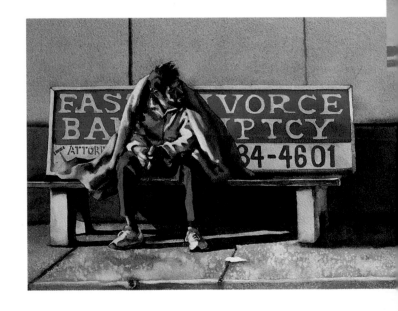

Karen Frey
Fast Divorce and Bankruptcy
14" x 21" (35.6cm x 53.3cm)
Lana Aquarelle 140 lb. rough

A **Lael Nelson**
Cake Walk
17.5" x 20.5" (44.5cm x 52.0cm)
Watercolor board cold press
Mixed media: Opaque watercolor

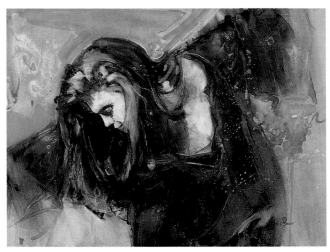

△ **Carla O'Conner**
Black Gown
22" x 30" (55.9cm x 76.2cm)
Hot press watercolor board
Mixed media: Interference pigments

▷ **Donna L. Swigert**
Prissy's Bonnet
18" x 22" (45.7cm x 55.9cm)
140 lb. Acid free cold press

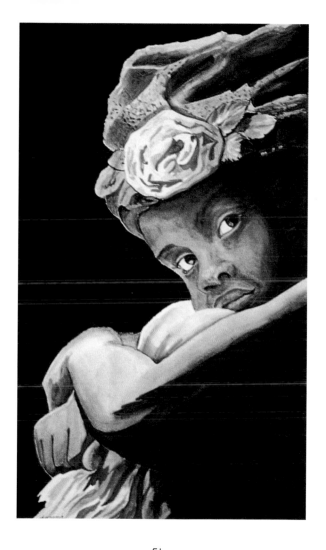

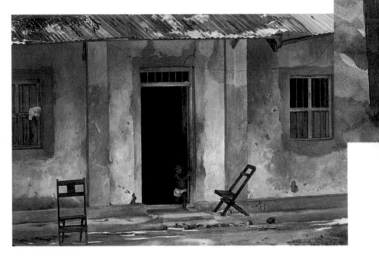

△ **Edwin L. Johnson**
Into the Light
21.5" x 31" (54.6cm x 78.7cm)
Strathmore 112 lb. rough, Crescent
100% rag watercolor board

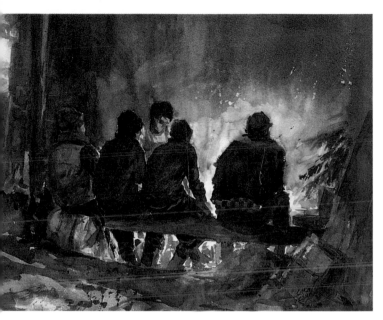

△ **Carlton B. Plummer**
Winter Campout
21" x 28" (53.3cm x 71.1cm)
Arches 140 lb. cold press

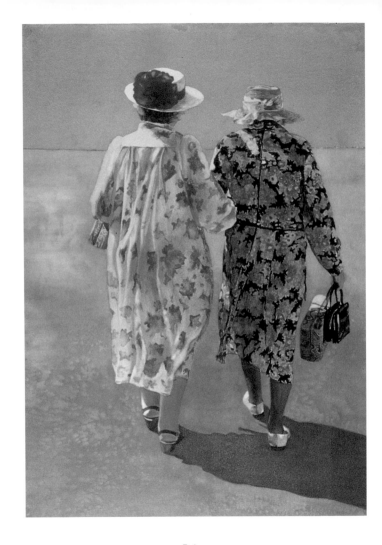

54
||||

Pauline Geerlings
Casey the Cat
22" x 30" (55.9cm x 76.2cm)
Arches 120 lb. cold press

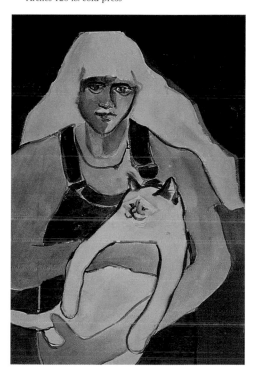

Nedra Tornay,
N.W.S.
Two Women
30" x 22" (76.2cm x 55.9cm)
Arches 300 lb. rough

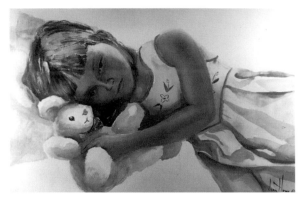

A **Joan Howe**
Pinkie
15" x 22" (38.1cm x 55.9cm)
Arches 140 lb. cold press

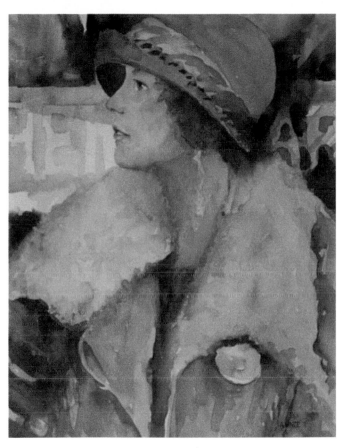

△ **Ann Perry**
I Remember Mama
29" x 21" (73.7cm x 53.3cm)
140 lb. cold press

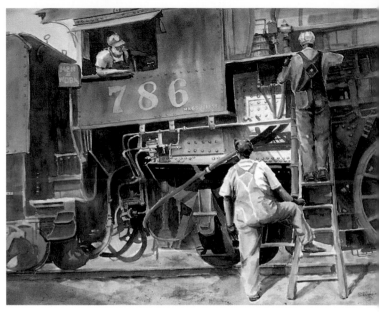

A **Dorothy D. Billman**
Men at Work
21" x 28" (53.3cm x 71.1cm)
Arches 140 lb. cold press

▽ **M.E. Procknow**
African Genesis
26.5" x 20" (67.3cm x 50.8cm)
Crescent hot press illustration board
Mixed media: Acrylic

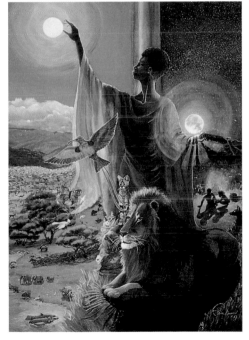

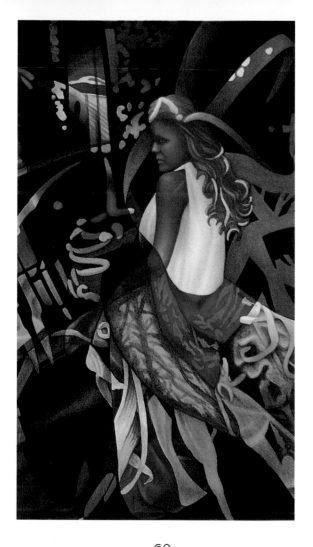

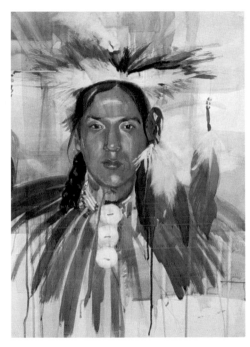

△ **Molly Gough**
Indian Man #1
22" x 28" (55.9cm x 71.1cm)
4-Ply plate bristol

◁ **Rich Ernsting**
To the Light Fandango
18" x 28" (45.7cm x 71.1cm)
Arches 300 lb. cold press

▽ **Elizabeth H. Pratt**
John's Father
25" x 19.5" (63.5cm x 49.5cm)
Strathmore 3-ply 100% rag plate bristol

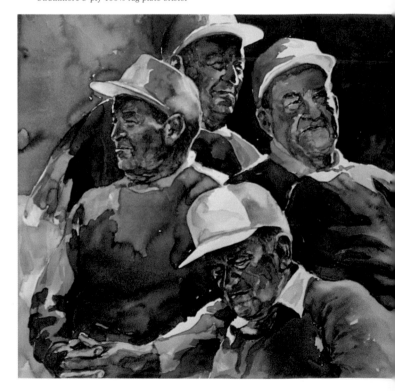

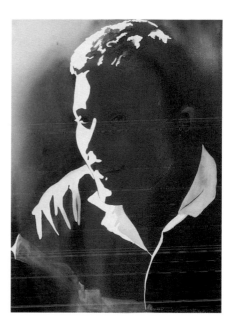

A **Jane Higgins**
Jeffrey Darlin'
22" x 30" (55.9cm x 76.2cm)
Arches 140 lb. cold press

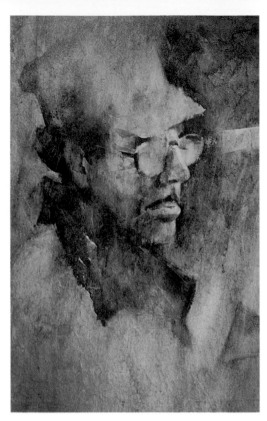

△ **Dean Davis**
Rusty Rails
16" x 20" (40.6cm x 50.8cm)
Scyntilla
Mixed media: Gouache

▽ **Sally Bookman**
Just Good Friends
17" x 17" (43.2cm x 43.2cm)
Lana Aquarelle 140 lb. cold press

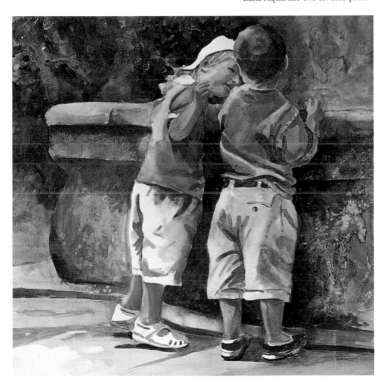

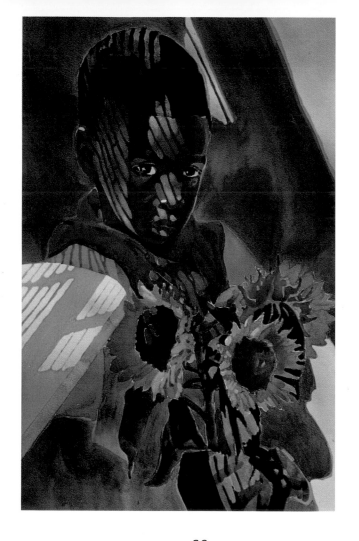

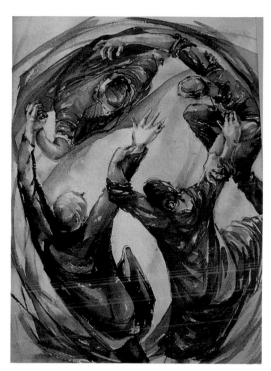

△ **Greta Aufhauser**
Harvest Dance
36" x 24" (91.4cm x 61.0cm)
Arches 140 lb.

◁ **Rhett Thurman**
Cameron II
22" x 30" (55.9cm x 76.2cm)
Mixed media: Winsor & Newton

▷ **Robert L. Barnum**
Church Social
22" x 30" (55.9cm x 76.2cm)
Arches 300 lb. rough
watercolor paper

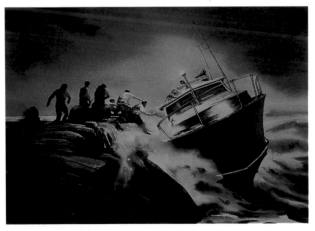

△ **Gayle Denington-Anderson,**
A.W.S.
4th of July at Edgewater Park
15" x 22" (38.1cm x 55.9cm)
Arches 140 lb. rough surface

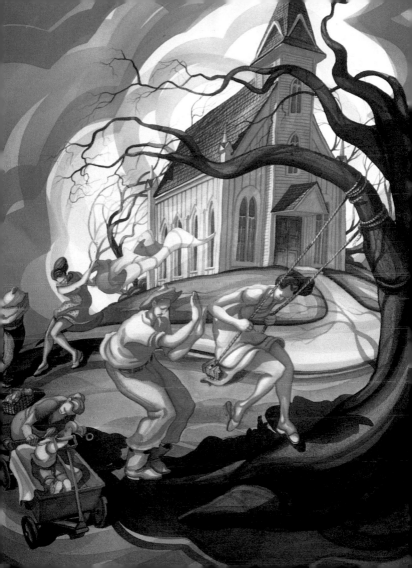

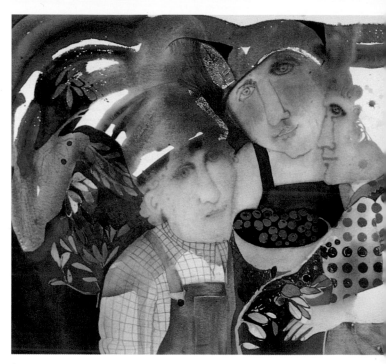

△ **Karen B. Butler**
Blueberries
22" x 30" (55.9cm x 76.2cm)
Arches 140 lb. cold press

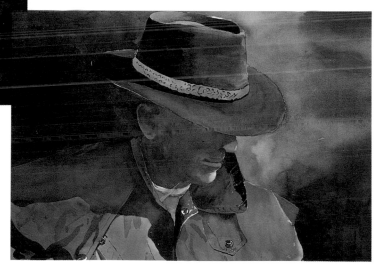

▽ **Joyce D. Laws**
Man from Snake River
22" x 30" (55.9cm x 76.2cm)
Arches 140 lb. cold press

Paul G. Melia
The Great American Dream
38" x 30" (96.5cm x 76.2cm)
#110 and #310 Crescent illustration board
Mixed media: 100% Permanent pigmented inks

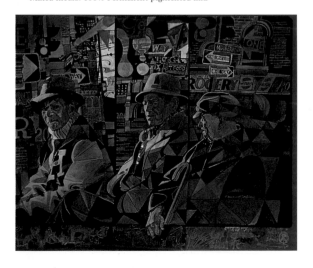

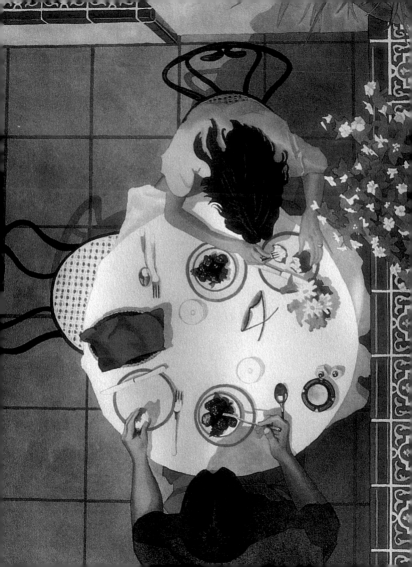

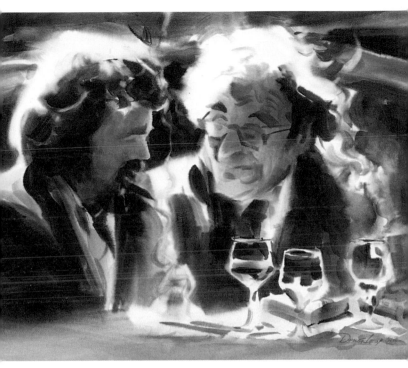

A **Doug Lew**
Pub Talk
28" x 20" (71.1cm x 50.8cm)
Arches 140 lb. cold press

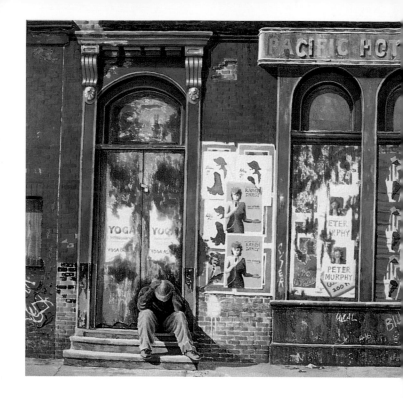

Becky Haletky
West 14th Street
20" x 28" (50.8cm x 71.1cm)
Arches 140 lb. rough

Louise M. Lundin
Rashmi
14" x 20" (35.6cm x 50.8cm)
Arches 140 lb. cold press
Mixed media: Pencil outline

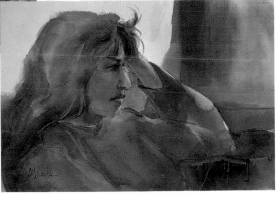

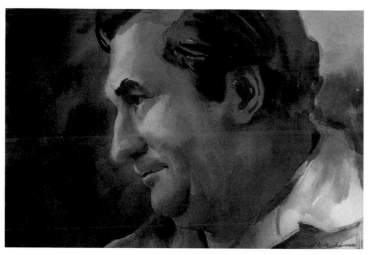

A **David R. Becker,**
M.W.S.
Dad
12" x 17" (30.5cm x 43.2cm)
Arches 300 lb. rough

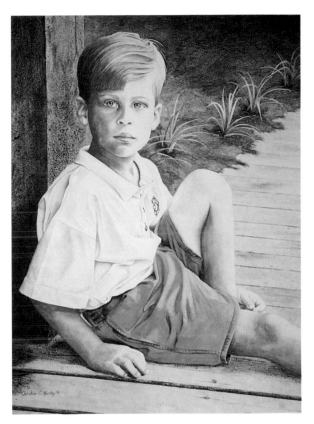

△ **Christine C. Hurley**
Sitting in the Dock of the Bay
22" x 29" (55.9cm x 73.7cm)
Strathmore 500 Series bristol regular

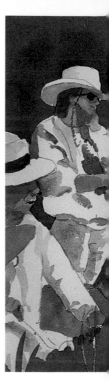

∇ **Karen George**
The Final Act
22" x 30" (55.9cm x 76.2cm)
Arches 140 lb. cold press

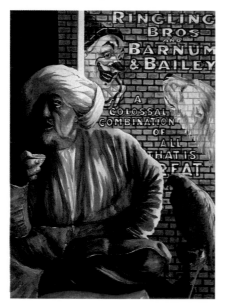

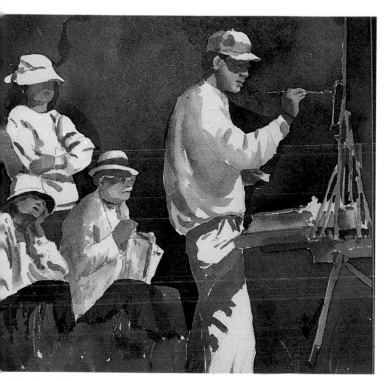

A **Anne Allemann**
Rapt Attention
14" x 28" (35.6cm x 71.1cm)
Arches 140 lb.

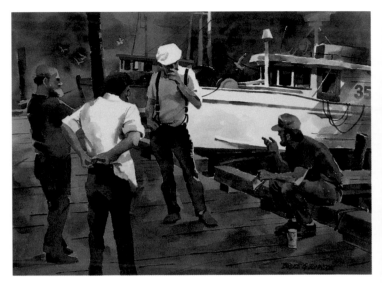

△ **Bruce G. Johnson**
Pier Talk
20.5" x 27.5" (52.1cm x 69.9cm)
Arches 300 lb. cold press

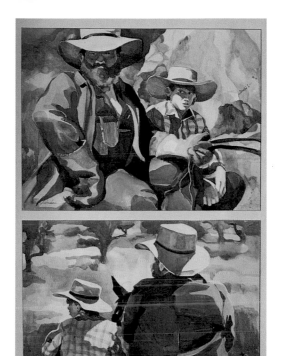

△ **Leatrice Joy Richardson**
Diptyck
24" x 38" (61cm x 96.5cm)
Arches 140 lb. cold press

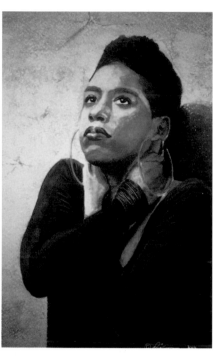

△ **Henry W. Dixon**
Michelle
16.25" x 20.25" (41.3cm x 51.5cm)
Fabriano 300 lb. rough

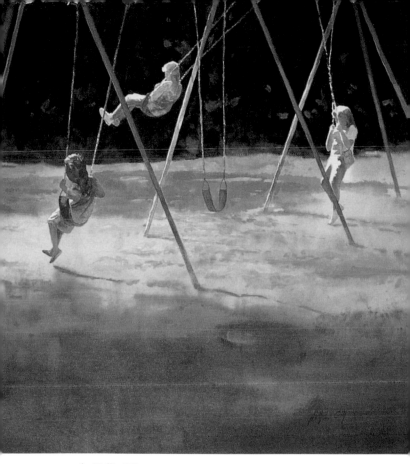

△ **Nellie Gill**
Friends
22" x 30" (55.9cm x 76.2cm)
Arches 300 lb. cold press

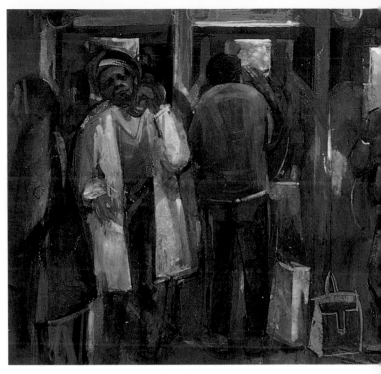

△ **Hella Bailin,**
A.W.S.
Telephone Booths
15" x 23" (38.1cm x 58.4cm)
Illustration board cold press

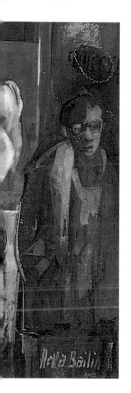

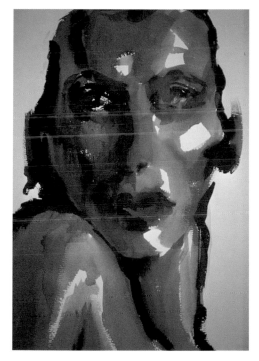

▷ **Lance R. Miyamoto**
Herodias
24" x 19" (61.0cm x 48.3cm)
Arches 140 lb. rough

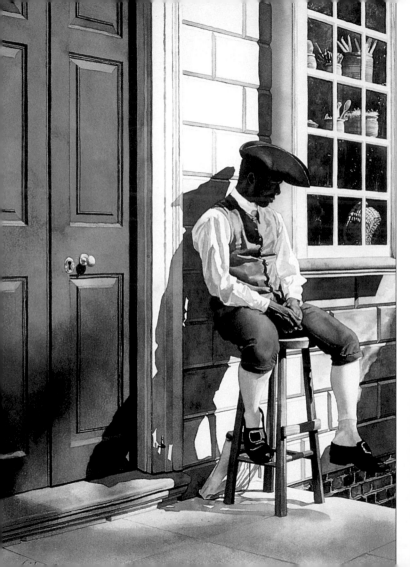

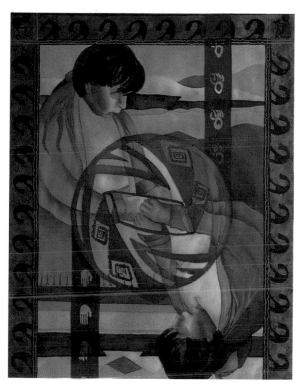

△ **Beth Porter Johnson**
Reflecting Spirits
29" x 21" (74.0cm x 53.3cm)
Arches 140 lb. cold press
Mixed media: Transparent watercolor,
acrylic, gouache

◁ **Heide E. Presse**
A Williamsburg Still Life
16" x 25" (40.6cm x 63.5cm)
Arches 300 lb. cold press

∀ **Paul G. Melia**
Lady of the House
40" x 43" (101.6cm x 109.2cm)
#110 Crescent illustration board

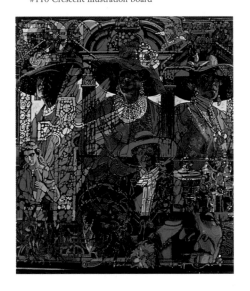

▷ **Priscilla Krejci**
Senior Tourists
22.5" x 16.5" (57.2cm x 41.9cm)
Arches 140 lb. cold press

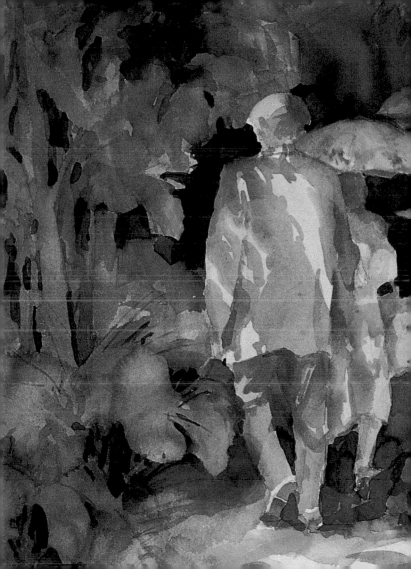

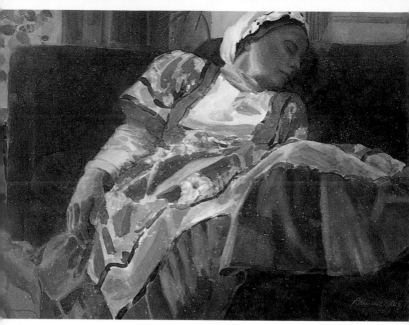

A **Joan Ashley Rothermel,**
A.W.S.
Shabbos Nap
22" x 30" (55.9cm x 76.2cm)
Arches 140 lb. cold press
Mixed media: Gouache, lightfast inks

∀ **Carolyn Lord**
Two Lemons
11" x 15" (27.9cm x 38.1cm)
Fabriano 140 lb. rough

▷ **Gary Akers**
Otis 15
36" x 24" (91.4cm x 61.0cm)
100% Rag smooth surface

A **Judith Randall**
Window to a World
18" x 20" (45.7cm x 50.8cm)
Crescent cardboard illustration board
Mixed media: Brumbacher tube
watercolors, Rapidograph pen and ink

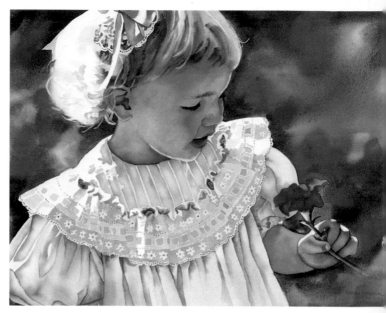

△ **Wendy Mattson**
Brie
33" x 40" (83.8cm x 101.6cm)
300 lb. Cold press

INDEX • DIRECTORY

Edwin L. Johnson
52
7925 North Campbell Street
Kansas City, MO 64118

Anne Kittel
39
1263 Sunbury Drive
Fort Myers, FL 33901-8738

Howard Kline
insert
150 Main Street
Rockport, MA 01966

Priscilla Krejci
89
4020 Fiser
Plano, TX 75093

Joyce D. Laws
71
1041 44th Street
Sacramento, CA 95819

Doug Lew
73
4382 Browndale Avenue
Edina, MN 55424

Fealing Lin
28
1720 Ramiro Road
San Marino, CA 91108

Luis Llarina
30
1937 "L" Avenue #1
National City, CA 91950

Carolyn Lord
91
1993 De Vaca Way
Livermore, CA 94550-5609

Louise M. Lundin
75
2330 Fifth Avenue West
Hibbing, MN 55746

Joseph Manning
10
5745 Pine Terrace
Plantation, FL 33317

Wendy Mattson
94
P.O. Box 1063
Placerville, CA 95667

Paul G. Melia
72, 88
3121 Atherton Road
Dayton, OH 45409

Joanna Mersereau
13
4290 University Avenue, #14
Riverside, CA 92501

Morris Meyer
19
8636 Gavinton Court
Dublin, OH 43017

Lance R. Miyamoto
85
53 Smithfield Road
Waldwick, NJ 07463

Mary T. Monge
44
78 Allenwood Lane
Laguna Hills, CA 92656

Judy Morris
29
2404 East Main Street
Medford, OR 97504

Donald A. Mosher
17
5 Atlantic Avenue
Rockport, MA 01966

Gloria B. Nehf
insert
700 Lindell Blvd.
Delray Beach, FL 38444

Jean R. Nelson
40
1381 Dow Street NW
Christiansburg, VA 24073

Lael Nelson
48
600 Lakeshore Drive
Scroggins, TX 75480

Carla O'Connor
50
3619 47th Street Court NW
Gig Harbor, WA 98335

Kay Ornberg
20
5716 South University Drive
Fargo, ND 58104

Ann Perry
57
955 Maple Ridge Road
Palm Harbor, FL 34683

Carlton B. Plummer
53
10 Monument Hill Road
Chemsford, MA 01824

Elizabeth H. Pratt
62
P.O. Box 238
Eastham, MA 02642

Heide E. Presse
86
15914 Farringham Drive
Tampa, FL 33647

Bonnie Price
24
2690 East Villa Street
Pasadena, CA 91107

M.E. Procknow
59
1201 Cozby East
Forth Worth, TX 76126-3601

Judith Randall
92
2170 Hollyridge Drive
Hollywood, CA 90068

Donald G. Renner
25
540 Holly Lane
Plantation, FL 33317

Leatrice Joy Richardson
81
3923 Clearford Court
Westlake Village, CA 91360

Clarice Roberts
26
1474 Homestead Lane
Hayward, CA 94545-3133

Joan Ashley Rothermel
90
221 46th Street
Sandusky, OH 44870

Jeanne Ruchti
46
4639 Meadowlark Street
Cottage Grove, WI 53527

Robert G. Sakson
16
10 Stacey Avenue
Trenton, NJ 08618-3421

John Salchak
insert
18220 S. Hoffman Ave.
Cerrtos, CA 90703

Linda Savage
42
7910 West Red Coach Avenue
Las Vegas, NV 89129

Betty Lou Schlemm
34
Caleb's Lane
Rockport, MA 01966

Charles Stratmann
47
5084 Atlantic View
St. Augustine, FL 32084-7140

Donna L. Swigert
51
625 Lakeview Drive
Logansport, IN 46947

Rhett Thurman
66
103D Church Street
Charleston, SC 29401

Nedra Tornay
54
2131 Salt Air Drive
Santa Ana, CA 92705

Linda J. Chapman Turner
38
Rt. 2 Box J
Jane Lew, WV 26378

Sabina Harte Turner
35
P.O. Box 1657
Sutter Creek, CA 95685

Dee Wescott
43
165 Devonshire
Branson, MO 65616

Arne Westerman
21
711 SW Alder #313
Portland, OR 97205